MARLENE DUMAS

SELECTED WORKS

ZWIRNER & WIRTH

32 E 69 St New York NY 10021

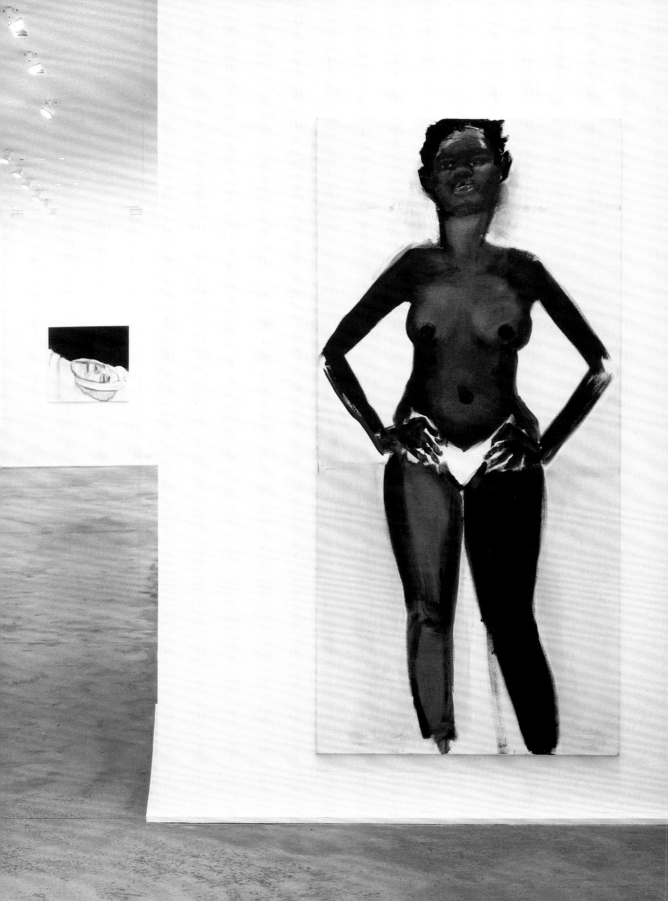

Marlene van Niekerk

Seven *M*-blems for Marlene Dumas.

Emblem:
1. A picture with a motto or set of verses intended as a moral lesson.
2. An object or the figure of an object symbolizing and suggesting another object or an idea.
3. A symbolic object used as a heraldic device.
4. A device, symbol or figure used as an identifying mark.

(Note: The *M*-blem is a kind of problem. It could cause a blemish.)

First *M*-blem: *M*iss Quoted.

In 1992 Marlene Dumas titled an exhibition in the Van Abbe Museum in Eindhoven, the Netherlands, "Miss Interpreted." It was a half-joking, half-serious response to the many interpretations that her work has elicited. Marlene Dumas has always responded to her exegetes. She has collected her previously published aphorisms, arguments and musings under the title *Sweet Nothings* (Amsterdam: Uitgeverij De Balie, 1998). So "Miss Interpreted" has risked the possibility of becoming "Miss Quoted" and of being kept to her word:

"I write about my own work because I want to speak for myself. I might not be the only authority, or the best authority, but I want to participate in the writing of my own history…. I don't like being paternalized and colonized by every Tom, Dick or Harry that comes along (male or female)."

"I don't like pompous, purple prose; rather give me a cruel, cold text, with a touch of evil and a handful of salt to rub in the wounds."

"I write because I love words. Or rather, what is more erotic than a body with sex appeal? A sentence with sex appeal."

*"I know that neither images nor words,
can escape the drunkenness and
longing caused by the turning
of the world.
Words and images drink the
same wine.
There is no purity to protect."*

In writing about the work of Marlene Dumas, one would be missing the point if one thought to construe *Sweet Nothings* as *Stormy Weather*. Preferably, one should aim for the better of two worlds. Rather than argue doggedly along Dumas's proposals, one should try to play according to the style of the quotes above. One could therefore enter the dumbfounding maze of this artist's imagination at a gallop or at a leopard crawl. Tiptoeing would have to be ironic. Any form of capturing is out of the question.

(Warning to the reader: "*Take your healing hands off my broken sentences.*")

Second *M*-blem:The *M*agpie.

"My brain is a compost heap.
My art a compound expression.
As a magpie collects everything that glitters
as a dung beetle collects everything that stinks
so my savage joys are brought about."

The current exhibition brings together works by Marlene Dumas dating from 1987 to 2002. Some of the works were grouped and formerly exhibited together under one title, such as The Secret, originally part of the exhibition *Not From Here* (Jack Tilton Gallery, New York, 1994). Others, like *Face,* 1987, were conceived of as single works in between the production of groups.

As installed here, in the two main exhibition spaces at Zwirner & Wirth, the oil paintings offer a strong sample from the parade of "savage joys" that Dumas has tirelessly marched past her beholders: First the women: a blue-black Twiggy with thunder thighs staking her claim (*My Place*, 2000); six brides posing in a row (*Ryman's Brides*, 1997); a frivolous porn model displaying her behind (*Velvet and Lace (Schnabel Meets Baselitz)*, 1999) and finally, a more demure redhead in a series of successive embraces of her dark partner (*Couples*,1994).

On the way to the next room, two portraits engage viewers from opposite sides: on the left a small baby's face in warm colors looking upward, its tiny pursed mouth and dark eyes exclude the viewer from its innocence. Across the passage a more experienced face, in bruised blues and grays, fixes its asymmetrical eyes at the viewer, its mouth skewed in withholding.

In the next exhibition space, the mystery deepens. The anxiety index rises. The colors are somber. There are no eyes here to meet our gaze. There is a dead man with a bound jaw (*The Deceased*, 2002), three prisoners in a row (*The Blindfolded*, 2002), a child that turns its back on us (*The Secret*, 1994) and a black baby sleeping upside down (or is she being born, or is she maybe chained?). A little to the side another toddler is the first to face us again, its arms raised and crossed high over its chest, its face anxious. A line of writing runs behind the head. The black handwritten words "un - titled," suggest barbed wire (*Untitled,* 1991).

Add to the paintings the subjects of the works on paper in the top room and one has indeed entered irrevocably into the life of the ghosts and angels with which Dumas has populated the world. Here one finds, among others, a strip-comic-like depiction of six (lesbian?) up and unders (*Two of the Same Kind*, 1993); a triptych of a quizzical (black?) figure kneeling ever lower into a (melancholic?) dream of a continent (*Thinking About Africa*, 1991); a woman's face, distraught with sorrow (*Magdalena*, 1995); a sixties S&M girl glowering through weals of mascara (*Bizarre (60's)*, 1993) and a wild-haired figure with blue breasts (*Voodoo Child*, 1996).

Apart from the characteristic overt references to other artists (Ryman, Reinhardt, Schnabel, Baselitz), to different worlds (Africa, war, intimacy, pornography, infancy, childhood, traditional magic) and literary traditions (the Bible, folklore, popular idiom and popular song lyrics), the works also exemplify quite a representative sample from the vast register of expressive modes, methods and techniques that the artist has developed over the years. In the ink wash and watercolor works, one sees in turn a starkly graphic sweeping delineation reminiscent of the cartoon, a light lyrical ink wash unbound by line (bound instead by something like the quivering meniscus of water in a brimming glass), a free combination of line and wash expertly exploiting the effects of leaking and bleeding, a triptych in crayon and collage (*Thinking About Africa*,1991) clearly executed in Dumas's humorous one-pose-leads-to-another mode.

Similarly, the paintings illustrate a varying combination of graphic and painterly techniques, creating in most cases an effect of both carefully modeled depth and carefully maintained flatness, at once pulling the eye "through" suggested space and stopping the eye at the surface, luring the viewer "into" the figurative dimensions and at the same time pulling the viewer back onto the physical plane. It is first and foremost through this technically effected ambiguity that the viewer is tricked into play. A unique visual realm proffers itself in each work, one that is neither similar to a commanding vista through an open window, nor to a secondhand reflection in a mirror. Beyond the vista and the flat reflection, it is a third visual possibility that here engages the viewer, one that makes her an accomplice to magpie work: The surfaces of these works by Dumas are neither "soft" nor "hard" but rather like membranes, skins, structured or rather "savaged" (washed, wiped, marked) to permanently attract and reject the eye that wants its rest too soon. Thus teased and forbidden, the eye is here recruited for the perverse pleasure of sustained desire, that is desire for its own sake within a field of indefinitely deferred meaning. As Dumas writes:

"ART
like an occult science is
an ancient ritual as dangerous
as the first flare of attraction
between two people –
an unreliable situation
with unpredictable consequences."

Third *M*-blem: The *M*onitor.

Monitor:
1. One who warns, or instructs; overseer.
2. A student appointed to a teacher.
3. A receiver used to view the picture picked up by a television camera.
4. A device for observing a biological condition or function, like that of the heart.
5. A small modern warship with a shallow draft for coastal bombardment.
6. A raised central portion of a roof, having low windows or louvers for providing light and air.

In 1963 when she was about ten years old, a child in the "Old South Africa," Marlene Dumas drew a cartoon of a Miss World lineup (Fig. 3). The pertly bosomed and conspicuously waisted contenders to the throne of perfect beauty press together in identical poses on the stage, arms and legs in a uniform stance, lips smiling in unison. The models sport the hallmarks of 60s fashion: the beehive hairstyle and the bikini swimsuit. Their ethnicity is graphically marked and explicitly annotated in a childlike handwriting at the bottom. It was this type of drawing that Dumas, as a young girl, drew on the back of cigarette boxes for her parents' male guests. It had them exclaiming that she was destined for the arts.

Looking back, one can only conclude that this early drawing announced a lifelong preoccupation with and sensitivity to the female figure in popular and contemporary images. Dumas seems to be constantly monitoring the world of the front page, the shout line, the caption, the phantasmagoric universe of advertising, fashions and entertainment stars. The consumer-driven world in its endless photographic and cinematographic self-display interests her because of the pressure it puts on the integrity and identity of everybody who is exposed to it. Dumas justifiably wonders whether she is a "closet moralist." And sometimes indeed a pseudo-prophetic tone slips in:

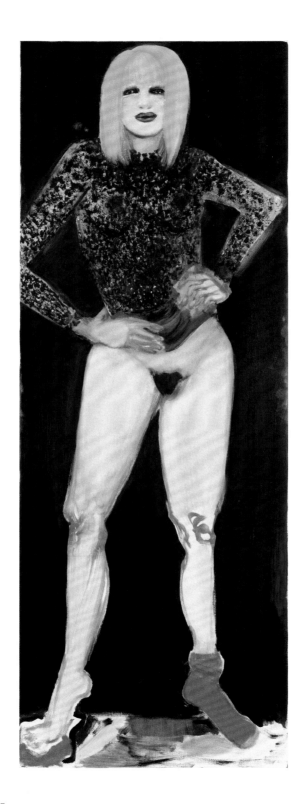

Fig. 1 *Miss January*, 1997

*"I have not come
to propagate freedom.
I have come to show the disease symptoms
of my time.
I am a good example of everything
that is wrong with my time."*

Elsewhere, however, she states in a tone of mock complicity with the artifice of the world:

"The images I deal with are familiar to almost everyone everywhere. My 'models' have all already modeled for someone else. There ain't no virgins here."

It can already be inferred from these quotes that Dumas would invariably involve her secondhand models, already named, framed and staged by the fashion and sex industries, in a highly personalized dynamic of critique and empathy. Her work also often contains more or less conspicuous autobiographical traces.

The first painting one sees on entering, titled *My Place* (2000), forcefully engages the genre of the female nude. This black woman is not nude but naked, a distinction most carefully elaborated by John Berger (*Ways of Seeing*, p. 45 ff.). Her attitude, although clearly a pose, belies passivity or victimization. The imperious figure in strong dark blue-blacks stands her ground. Arms akimbo, head raised, she lays defiant claim to her autonomy. Yet the thin twigs of the arms of the typical fashion model seem to be contradicted by her plumpish breasts and thick thighs. Her "broken" elbows and the absence of feet further stress the vulnerability of the figure.

As is often the case when looking at a work by Dumas, there is a slippage from first impressions to lasting doubts. Through the incompleteness of the limbs and the deliberately "unfinished" spaces between the hip-clutching fingers, the white undergarment worn by this black model becomes visible as canvas consciously left unpainted. One is reminded of the pose in another Dumas painting: *Miss January* (1997) (Fig. 1), pointedly without panties, grasping her hips with electrified fingers. Both these paintings of female nakedness would seem to carry a subtle comment on the less complicated and solidly decorative stance of the posing male, one elbow bent, in *Jeune Arabe* by Kees van Dongen.

As far as the depiction of commercialized sexual play is concerned, Dumas does not flinch from doing the "dirty work." She challenges and surprises her viewer by giving a heady hedonist spin to the project. Several images in the current exhibition exemplify the "red district" dimension of her tireless investigation of the human spectacle. One of them, the frivolous *Velvet and Lace (Schnabel Meets Baselitz)* (1999), belongs to the family of figures originally exhibited in 1999 under the title *M D-light* (Frith Street Gallery, London).

With obvious delight, Dumas renders the self-pleasuring pseudo-acrobatic pose of this transparent blue sister of *Dorothy D-Lite* (1998) (Fig. 2), graphically highlighting the crescent contour of the vulva. With this formal decision to highlight the sexual parts in *Velvet and Lace*, Dumas creates interesting content: She sets up a relationship between the most intimate seam of female anatomy and the similarly highlighted frilly lace holding up the velvet stockings. In the mock boudoir of pornography, she seems to imply, the sexual parts, supposed to be the hidden surprise, are externalized as part of the packaging. The flesh has become lace.

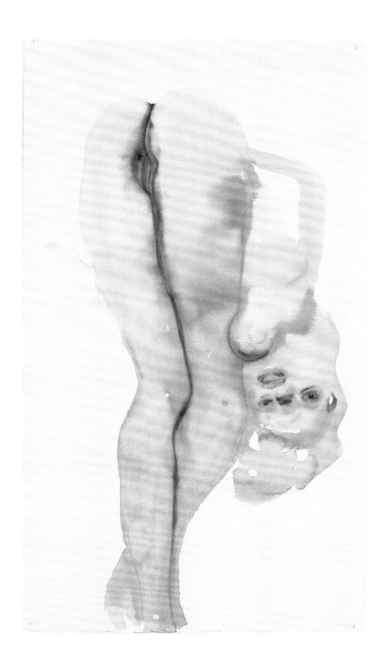

Fig. 2 *Dorothy D-Lite*, 1998

The tension in *Velvet and Lace* derives from the fact that although the female figure is in a state of sexual self-abandon, the actual actions towards which she seems to tumble will happen offstage, at least for some part in the viewers' imagination. Emancipated from shame, in her giddy availing of herself, the girl of *Velvet and Lace* is an almost fairylike apparition inhabiting a midnight city dream.

Through the firmness of the oil paint and accentuated outlines, but also through the restraint of the gestures, the figures in *Couples* (1994) seem to be engaged in more solid business. The colors here are muted, except for the orange hair of the woman and the contrasted dark limbs of the male figure. The black limbs function formally as a framing device, "containing" not only the woman's shape but also her advances. Though lighter in tone, it would seem that the female figure has an overall heavier investment in these embraces. Her head inclined this way then that, her feet carefully held together, could suggest a plea for closeness from a reluctant partner. His opaque, partly obscured black head and the stiff clutch of his hand in the second embrace cause unease in the viewer, maybe through the echo here of Munch's mutually consuming couples and especially of his similarly color-contrasted figures in *Death and the Maiden* (1893). The repetition of the pose also rings with a melancholy of satiation that, in all likelihood, translates a sense of the exhaustion of the topic of the female nude. The woman here offers us only her back, making herself available herself to her partner who is obscured to us – a situation defying the frontal rhetoric of classical paintings of the female nude.

In the upstairs room, several drawings explore the same sexual themes. In the drawing titled *Head Rest* (2001), we are presented with a reverie on the same theme as in *Velvet and Lace*, of an upside-down female figure with dangling breasts. The head in the bottom right corner, a dark focal point in the whole, is attached to the body at a perilous angle. Its features, like those of the face in *Velvet and Lace*, are unclear and as the title indicates, it functions solely as support. The title can also be taken to mean that the head can "rest," or that the head is a "left over." It quite literally looks as if, within the accident range of the watery medium, the head was a catchment area for runoff color. All in all, the drawing realizes a tension between watery vagueness and uncomfortable physical position.

The sequence of positions depicted by the other couple in this exhibition, *Two of the Same Kind* (1993), seems to express boredom rather than pleasure. The gymnastics of Dumas's figures as they perform their little routine of "earthly delights" seem like closeups of the antics of the figures in Bosch's panoramic dream of hell and paradise. Here, however, they have no support except each other's bodies, least of all the emblematic support of theology.

*"The muse is exhausted
too many bodies and not enough
soul. She's got the porno blues."*

Fourth *M*-blem: The *M*use (Mnemosyne).

Mnemosyne, muse of memory, mother of the nine muses of the arts, sister of Cronos, God of time.

*"The muse is exhausted
because linear time has been
abolished. Everything is here and
now and present tense."*

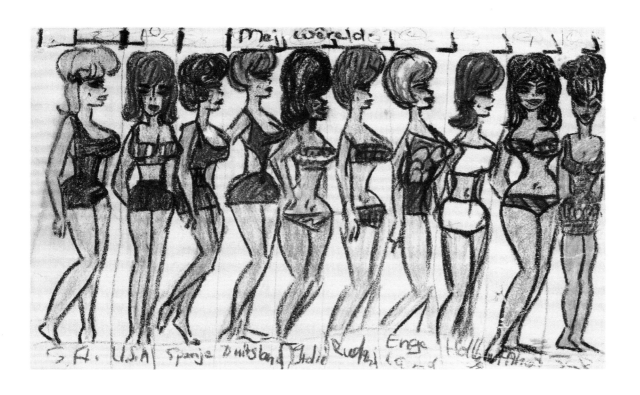

Fig. 3 *Mej Wêreld [Miss World]*, c.1963

If Dumas's muse is, on the one hand, tired of her complicity with the popular and the contemporary, especially in its exploitation of the body, and if she stands stumped before an overexploited genre of the female nude, a recuperative moment seems none the less to be found in her engagement with the history of painting, her affairs and debates with the old masters, her memory of and reflection on the figurative traditions of the past and an acute understanding of the relation of painting to time.

In an early memo, Dumas states that she wants to be a referential artist and that reference deals with the already named (read: "already painted"). As much as the imagery of the present day fuels her imagination, the past of painting is palpably present in Dumas's work. Already as a young artist looking to find her own distinctive signature, the muse of memory seemed to be indispensable for the setting up of a mnemonic scheme, through which the accomplishments of the past could be listed and ordered. On a note page dated 1989, under the heading *Thinking about Paintings of the Human Figure*, Dumas at the time jotted down a revealing index:

"Holbein: the simplicity," "Rembrandt, the warmth of the flesh," "Vermeer, the dignified distance," "Courbet, the heaviness of the flesh," "Manet, the master of the unrelated figure." And so it goes, list upon list, with typifying annotations: Goya, Munch, Nolde, Bacon, De Kooning, Lucien Freud, Alice Neel, Frida Kahlo, Joseph Beuys, Andy Warhol and many more.

With time and growing confidence, the mood of this early self-interrogation has clearly changed. What was then a search for a distinct personal style has now become a much lighter and playful engagement with accomplishments of the past and a relaxed recognition of affinities and related areas of investigation; for instance, the isolation of the human figure in a space containing no or few other situating contours. Already in 1993, Dumas states this newfound ease:

"I do not have artists or painters as heroes. I like and use bits and pieces of many, many artists and non-artists. I cannot exist without others. They are my burden, my inspiration, my subject matter and object matter."

In the current exhibition, two paintings, through their titles, reveal Dumas's active and literal "re-membering" of fellow artists. The one, *Reinhardt's Daughter* (1994), engages with the use of black in the minimalist paintings of the Lutheran mystic Ad Reinhardt (1913-1967). The other, *Ryman's Brides* (1997), takes issue with the materialist Robert Ryman's all-white paintings. Both of Dumas's paintings engage with the extreme refusal of the pictorial in these painters' work, while recognizing the radical positions that they have developed.

The painterly effects in *Ryman's Brides* are richly suggestive. Not only are all the hues of white explored but also the white modulations of transparency, glossiness, lace and embroidery. The vigorous brushwork carries obvious reference to Ryman's view of painting as performance--the entire painting vibrates with brushstrokes. Nevertheless, although confirming Ryman's gestures in all the shades of white, Dumas also wants to retain the representative dimension that he rejects. Her title seems to advise wistfully and humorously a marriage of the pictorial and the political to Ryman's painterly verve.

Dumas's painting is at first glance a picture of a group of six brides, posing possibly for a photograph at a mass wedding ceremony or a Bride of the Year competition. The coy expectant faces of (most of) the young women, their similar poses, uniform headdress and hair styling and elaborate dresses tell a critical story of class, race, gender and identity in Western society, much the same story, it could be noted as in Dumas's Miss World cartoon in 1963.

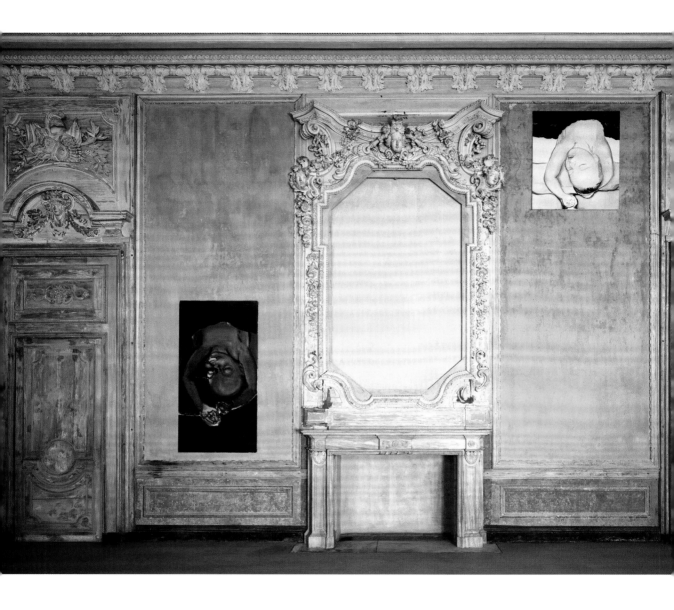

Fig. 4 at left: *Reinhardt's Daughter*, 1994; at right: *Cupid*, 1994

The question to be asked, however, is exactly how the formal execution is instrumental in either supporting, invigorating and, most importantly, in complicating or even undermining any simple pictorial message the viewer might construct.

The most succinct formal element (and the one that can most clearly be linked to the apparent "picture-purpose" of social critique) is the self-framing device of the composition of figures. It resides in the patterned detail of the brides' heads forming a convex line in darker tones at the top, repeated at the bottom by the detail of their feet in a more or less parallel curve. The brides seem "boxed in" from top to toe. But the "box" is sagging on top and bulging at the bottom. What could cause such pressure?

The vertical framing of the group is even more conspicuous. The weight of the four inward-leaning "white" brides on the right is contained by the slack vertical arm of the last little siren in line. What happens on the left, however, blows the assumed "picture-purpose" to smithereens. This is where the Dumas touch comes in and where Mnemosyne starts singing in her grainy voice. It is the old remembered song of the upstart bride, the wayward one with the wild view of things, the one who refuses to smile at the camera.

The red bride has next to her, a formal accomplice, a "black" bride with big feet confidently put at angles. The red-faced bride stays in queue but she strides in against the tide as if to admonish her meek-faced sisters. Her veil is full, like that of a nurse or a nun. Her arm stays in line, but her hand suggests sabotage. The fluffy layers of her gown suggest that she has "danced with the wolves." And so the "painting-reason" plays with the "picture-purpose." The red-faced bride plays both sides. She balances the painting and unbalances the plot. She is, above all, a formal force to be reckoned with. Her meaning is endlessly deferred by the play of painterly signifiers. She contaminates the entire white painting with little flecks of crimson, *traces of signifiance* that escape the tyranny of meaning (Roland Barthes, *Image Music Text*, p. 185). Exactly herein lies the joy of painting, making the "how" smiling at the "what," as Dumas has put it.

In *Reinhardt's Daughter* (1994), Dumas engages with the problem of color in another way. In its original context, *Reinhardt's Daughter* was twinned with another painting titled *Cupid* (1994) (Fig. 4). The two works are based on the same photograph of the painter's sleeping child. The languidly drawn outlines of the figure are slightly accentuated with yellowish and pinkish hues to offset it against the cream background. The figure carries allusions to the sweetly colored angel children of baroque churches and is clearly a white-skinned child. *Reinhardt's Daughter* is painted in dark colors against a somber saturated maroon-brown background. The pictorial reference is to a dark-skinned infant.

Dumas is interested here in Reinhardt's distinction between black as a symbol denoting the negative (e.g., of "race" or "evil") and black as a color devoid of any of these negative associations. She insists on exploiting both dimensions and on using the ambiguity to extend the expressive reach of the painting.

With specific reference to *Reinhardt's Daughter*, Dumas has written:

"You change the color
Of something and
Everything changes
(especially if you're a painter)."

Apart from the color issue, this work also engages with Reinhardt's radical art-as-art argument and his stand on the Western pictorial tradition. Its overt pictorial intent recalls Reinhardt's distinction between a

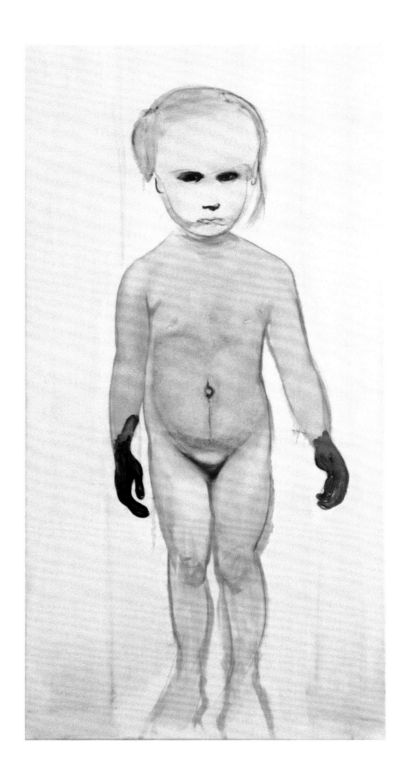

Fig. 5 *The Painter*, 1994

painting and a picture: a picture has a subject matter, tells some story, is photographic or cinematographic, and is sometimes hand-painted. The best and most effective pictures, according to Reinhardt, can be found in magazines and movies, and an artist concerned with communication and a larger public should get a job in mass publishing or the picture industry. An abstract painting, on the other hand, "is not a re-arrangement or distortion or recreation of something else. It is a totally new relationship." According to Reinhardt, artists who try to make pictures that are also paintings usually fail to do either well. They do it "to avoid both political responsibility and aesthetic criticism" (unpublished lecture, 1943, *Art as Art: The selected writings of Ad Reinhardt*, ed. Barbara Rose, 1975). Deep down, Dumas agrees, but she still *"tries to make works of art that look like pictures and act like paintings"* (Dumas, personal communication, 24 February 2005).

With *Ryman's Brides* and *Reinhardt's Daughter*, Dumas seems to insist that explicit coloring in the depiction of the figure invariably involves the artist in political questions. Aesthetic criticism is not avoided but complicated by formal choices of color. In both paintings the "totally new relationship" between formal elements is forged without loss of pictorial relevance or political point.

Fifth *M*-blem: The *M*eaning Maker.

"They are looking for Meaning as though it was a thing
As if it was a girl, required to take her panty off
as if she would want to do so, as soon as
the true interpreter comes along
As if there was something to take off." SN, p.58

In *The Secret* (1994), the painter deliberately instills a confusion between skin color and the colors of the painting. The pinkish neck and the blue-gray of the body make it impossible to label the child as black or white. In this case, the chameleon aspect of the child is closely related to the meaning imputed by the suggestive title (Dominic van den Boogerd, et al, *Marlene Dumas*, p.73).

The context in which the work originally appeared must also be taken into account. Originally grouped with several other works under the title *Not From Here*, with which Dumas made her solo debut in New York, the figure in *The Secret* seems like a twin of the figure in *The Painter* (1994) (Fig. 5), by now the best-known work of the group. Both are single iconic images which, through their isolation and large scale, seem to be assigned to a generation of divinities. Child gods they seem, both possessed by and wielding immense power. Most certainly they are "not from here" and yet both are familiar in their naked infant stance, the one full frontal, tummy protruding, with empty but culpable hands; the other presenting an "affronting" backside, buttocks firmly set, hiding something from one's view. Both are somehow alien in their undomesticated willfulness. Both are vulnerable yet imperious. Exactly what they are/were up to is not shown. Of the secret bearer one has only the gestures to go by, the concentration of the inclined head, the arms sharply bent at the elbows to bring the hands up close to the face. What is borne in those little paws? Something freshly killed? Something to eat? A fascinating turd? A frog to kiss? A button or a piece of string maybe, imbued with the value that privacy lends to trifles? Both the Painter and the Secret Bearer are performers in the eternal choreography of children's play; they move one deeply by the directness of their expression, their ability to be absolutely serious.

The offstage object that has been painted by *The Painter*, as well as the nature of the object hidden in *The Secret*, is a question of endless suggestion. Both paintings hold these absent meanings in abeyance. It is a latency that not only resides in the body language depicted here but also in the formal

and material qualities of the works themselves. *The Secret* resists a consistent finish, a "full" rendering of all the body parts in the same carefully and solidly molded way with which the back, buttocks and legs are painted. It is exactly the sketchiness around the ears, the bland pink plane of the nape and the splash of light pink at the feet that keep the painted surface alive to the eye. Again, it is not only the surface that is thus invigorated by incompleteness, the very content of *The Secret* itself is kept alive by these formally effective and conscious painterly in/decisions. For does a secret not "burn one's ears" and can a secret not "cast a glow" or "create a splash"? Thus the latency in both form and content add up to a potency of meaning, an inflamed sort of signifying, that cannot be tamed or fathomed however long one stares at these two paintings. In fact one stares all the longer in order to keep on feeling this lack of fixed meaning. It is a strangely heartening experience. To realize that one cannot tame, fathom or find final meaning is like letting out a breath that has been held too long. Dumas accordingly instructs:

"The Secret.

The painting is the secret.
The painting is not a
pervert with a raincoat.
It turns its back on you,
and minds its own business."

"Paintings are silent things. They don't tell us what to do."

"Human beings can't live without secrets.
That which is most important to one's well-being is not public relations."

Sixth *M*-blem: The *M*ediator.

One that mediates between parties at variance.
A mediating agent in a chemical or biological process.

To mediate:

To be in the middle.
To effect by action as an intermediary.
To act as intermediary agent in bringing, affecting or communicating.
To transmit as intermediate mechanism or agency.
To interpose between parties in order to reconcile them.

The avowal of being "in-between" and an insistence on ambiguity crops up time and again, not only when Dumas characterizes her work but also in her questioning of rigid oppositional thinking in the field of politics, gender and identity issues and practical ethics. This position is only seemingly one of irresolution. It has nothing to do with paralysis or impasse. It is a conscious moral stance that entails a vigorous intellectual activity of deconstructing opposites and yoking together contradictions in tense but fertile double binds. The aim of this effort, it would seem, is not to solve or lay to rest or close the gap between divergences in moral judgment or in formal and theoretical artistic possibilities. It is a continuing exertion to avoid the point of easy resolution. One often feels that the work of Dumas is a form of ironic propaganda for the virtue of the inconclusive, a struggle to keep verbal and pictorial meaning in a state of dramatic emergence.

One could, of course, speculate about the root cause of such a stubborn choice for unsettledness by the artist. Born in South Africa, living in Amsterdam, bearing a French surname, the artist now regularly travels the globe in the wake of moving exhibitions. A statement like *"I'm always 'not from here'"* could easily be reduced to a lament of the displaced and the culturally alienated.

Nevertheless, even if it is true that Dumas often refers to her geographical fate and its bearing on her work, there is much more to this. The in-between position not only pertains to that of being a stranger in strange countries, the artist herself wistfully attributes it to an inner split: "*I'm too half-hearted*", she writes, and *"I never quite know where I am."* More often, the recognition of marginality sounds less like a lament and more like a confession of intent or a regulative idea for creative activity. *"I am the third person"* she writes, *"observing the bad marriage between art and life, watching the pose and the slip, seeing the end in the beginning."*

The vocabulary that Van Gennep and Turner have developed for cultural anthropology might illuminate the value of the in-between state for artistic production in general. They have recognized the importance of in-between states in the rituals of primitive societies, usually referring to them as states of liminality (from *limen*, meaning threshold). The liminal phase of a typical rite of passage mediates between the isolation phase, where initiates are removed from society, and the reaggregation phase, when they are incorporated into normal society. Liminal phases occurred both in status-elevating rituals, such as those conducted to mediate the passage from boyhood to manhood, and in seasonal rites marking important points on the sun's ecliptic from the northern to the southern solstice. In the former type of ritual, the liminaries are of a specific group and the members are humbled and leveled to equip them for a higher status. In the latter, the liminaries include everybody in the community and no one is elevated in status at the end. Instead seasonal festivities often involve symbolic status reversal or the creation of make-believe hierarchies for the lower classes. The liminal phase of ritual is characterized by play and experimental behavior. It teems with monsters, masks and exaggerated gestures designed to stimulate renewed awareness of the values and beliefs of the tribe. Actions and processes are undertaken to discover something not yet known, to allow new ideas and symbolic forms to emerge. Free play and flexibility give this phase of ritual an immense capacity to portray, interpret and master radical novelty.

In modern post-industrial society, one can speak of a seeding of the processes and products of ritual into secular artistic forms. The liminal in this context can be modified to the term "liminoid." In the liminoid spaces of our day, the freedom to play and experiment radically with ideas, with images, with words often becomes the quirky and idiosyncratic work of specific individuals. In this context, it has become possible to speak, for instance, as Bakhtin and, after him, Julia Kristeva, of the "carnivalization" of the novel. With this term, she wants to indicate the kind of synchronic, dialogic, nonlinear, reversible multigenre work of Rabelais, Cervantes, Joyce and Woolf. The suggestion is that these types of novel may be throwbacks from seasonal rituals of reversal and of the fruitful chaos that they engender. Liminoid activity can be subversive in the way it proposes metalanguages with which to reflect on everyday languages or images with which conventional attitudes, values and symbols can be invested with modified or surprising content. One could link such metalanguage and reflexivity to phenomena of tribal liminality, where mockery of the gods and persons in authority and parodies of all that is high and mighty can be observed (Victor Turner, *Blazing the Trail: Way Marks in the Exploration of Symbols*, pp. 48-65).

Following Bakhtin, one can possibly speak of the "carnivalization" of the figurative tradition. It would take more extensive research to argue with whom this might have started in the history of figure painting. It would seem plausible though that Marlene Dumas could be seen as an important "carnivalizer" of painterly codes, as well as a refresher of a liminal dimension in portraiture.

A number of the strongest works in this exhibition can be read as liminal modulations of the themes of fear, death and sorrow. These can be imagined as states on the threshold from torture to death, from death to decomposition. The three men in *The Blindfolded* (2002) might have just been captured or tortured but not yet been freed or executed; the features of the dead man in *The Deceased* (2002) have set in rigor mortis but not yet decomposed. The artist offers these portraits to us as emoting simulators. They constitute us as ever-susceptible initiates into cruelty, loss and pain. At the same time, it must be remembered that "art emotions" are different from emotions in real life. The works mediate emotions in the subjunctive mode, the mode of "as if," "could be" or "may be," which is essentially the mode of play. The effects of formal abstraction open a space for these emotions to be investigated rather than literally suffered by the viewer.

Consider *The Blindfolded*. For once, here the eyes, probably the most accentuated expressive element in Dumas's paintings of faces, are completely screened. We strain to read these expressions. The rectangles of cloth form a discontinued strip over the two left-hand faces. On the bruised face of the right-hand man, the strip takes on the shape of a head bandage. This victim seems to bear it with less fortitude than his mates do.

Unable to read the eyes of these faces, we might, in our attempt to find out "what is going on," mimic the head tilt of the right-hand face, guessing the direction of his sideways gaze. It only leads us back to the blindfolds of the others. So we find ourselves at the same instance on the side of the blindfolded and that of the blindfolders.

On a different level we are also interrogated about the critical function of art in times of unutterable systematic cruelty of people to all sentient beings, and especially to those of their own kind. For want of eyes we ponder the mouths of these hapless men and remain speechless while imagining the thoughts of the one on the left: Where am I? Who are you? What is going to happen next?

We stand in front of this work humbled like initiates by the scarecrows in a ritual. These prisoners are "freed" by art, they have been "carnivalized "into mediators, leading an inquiry into the fraught world we live in. One could suggest that they function like the monsters and masks in the liminal phase of status-elevating rites of passage. They could prepare us for reincorporation in the world outside the gallery, as politically resensitized human beings.

Seventh *M*-blem: The *M*aterialist (and The *M*atter of Death).

"I paint because I am a dirty woman.
(Painting is a messy business.)"

However much Dumas, through her choice of subjects can be said to be an interpreter, monitor, mediator and commemorator of her times, it is her way with her materials that probably remains the most intriguing aspect of her work. One could venture to say that the material, more than a mere "medium" is itself her grounding subject or topic and that the specific relationship between her body and the surfaces she marks, constitutes "the matter" onto which all the other relationships in her work are grafted. This priority is suggested when she writes:

"[Painting] cannot ever be a pure conceptual medium. The more 'conceptual' or cleaner the art, the more the head can be separated from the body, and the more the labor can be done by others. Painting is the only manual labor I do."

That she has always had a soft spot for the action painters is well known. Traces of the physicality of action painting, of the rhythmic making of marks can often be discerned in her works. Dumas's notion of what painting, all painting, is, clearly confirms this:

"Painting is about the trace of the human touch. It is about the skin of a surface." SN 75. "Paintings exist as the traces of their makers and by the grace of these traces. You can't TAKE a painting, you MAKE a painting."

These traces can be left by a rational instrumental hand steadying itself on a maulstick, or by the entire body throwing itself "mindlessly" onto the canvas. In between these extremes, there are many possible degrees of instrumentality or spontaneity of the painterly gesture. One could suggest that Dumas's hand is neither a straight tool nor a blind groper but a trickster's hand that can marvel at its own sleight. It is a hand that is relied on for its ability to have useful accidents. It is a hand that is neither harnessed nor "left to its own devices" but "spoilt rotten" by a mind that wants to be entertained by things it could not have conceived of on its own. The hand is the translator of that which the painter does not know.

One could speculate therefore that Dumas practices a form of quickening painterly voodoo over the flat matter of the canvas and the paper, yielding to, while at the same time resisting, its flatness. The actions themselves point the way and lend to her faces and figures the quality of emergence, the vibration of the liminal. As she puts it herself:

"Art that moves you has something ungainly about it, it is in some way bound up with a combination of hesitation and something going wrong."

I do not think that it would be farfetched to suggest that Dumas, through some of these techniques, sometimes flirts with the "supernatural" in order to engage the viewer. This would entail employing the melodramatic codes of presentation usually associated with the esoteric realm, "ominous" dark colors, "spectral" pale colors, "holy" or "demonic" halos, transparencies, mistiness, fluidity. Of course, the suggestive colors need, in addition, to be coupled to codes of pictorial representation to heighten the suggestion of ghosts, angels, goblins, demons and the like. These beings "from another world" are made to brim with ephemeral life.

It is, however, when Dumas paints dead people, her latest artistic preoccupation, that the material itself is "understated," and the drama of "dead" matter in human form fills the stage. The typical Dumas theatricality of bringing the viewer into startling proximity with the human face on a scale most disquietingly larger than life is also pertinent in her *ars mori*. We are forced by these unanswering faces to look inward. The paintings unleash fantasies of our own dead countenance awaiting the living around the next corner.

The Deceased belongs to Dumas's most recent series of paintings and was originally exhibited in 2004 as one of a group at the Art Institute of Chicago, under the title *Time and Again*. The drama of *The Deceased* is effected by the stark contrast of a sloping horizontal divide right through the middle of the canvas where a whitish and a dark blue plane meet, articulating the horizon of a final landscape. The dark blue section above is much more than a negative space. Quite flatly and densely painted, one could surmise that it is intended to represent the alien and unsunderable force of Death, the most definite Other of life.

The viewer by implication also stands in this darkness, looking in upon the lifeless countenance. The impending decomposition of the flesh is stated by a hesitant graphic line articulating the contours of the

face in the lower half of the painting. The overbearing horizontality of the formal planes is checked by a series of verticals: the ruffs of the shroud, the square of the chin, the wrinkle underneath the mouth, the lips, the incision of the nose, the fold under the eyes, the line of the closed lids, the eyebrows and the edge of the forehead.

Formally, the horizontals and the verticals are brought into compositional harmony by the curved lines of the head bind that subtly suggests a cradle for the face. This last cradle, of course, is not for rocking off to sleep but to keep in place the treacherous jaw of the dead. In this case, the jaw is not quite locked so that the slightly parted lips allow a glimpse of the mouth cavity beyond the teeth. Through the dithering line with which the lips are rendered the suggestion of a tremor is evoked.

The sense of awe and pity produced by this painting, at once extremely intimate and starkly distant defies the descriptive. Only poetry, which is the opposite of description, could be quoted here as adequate response:

Aussi bas que le silence
D'un mort planté dans la terre
Rien que les ténèbres en tête

[As soft as the silence
Of a corpse planted in the ground
Nothing in his head but darkness…]

Paul Eluard, *La Figure Humaine*.

(Note: Except where indicated all quotes from the artist have been taken from *"Sweet Nothings."* Some inaccurate spellings have been corrected, sometimes lines written in verse form have, for the sake of coherence, been quoted as prose in the text.)

Bibliography

Barthes, Roland. *Image Music Text*. Translated by Stephen Heath. New York: Hill and Wang, 1977.
Berger, John. *Ways of Seeing*. London: British Broadcasting Corporation and Penguin Books, 1972.
Dumas, Marlene. *Sweet Nothings: Notes and Texts*. Edited by Mariska van den Berg. Amsterdam: Uitgeverij de Balie, 1998.
Reinhardt, Ad. *Art-as-Art: The selected writings of Ad Reinhardt*. Edited and with an introduction by Barbara Rose. New York: Viking Press, 1975; Berkeley: University of California Press, 1991.
Turner, Victor Witter. *Blazing the Trail: Way marks in the exploration of symbols*. Edited by Edith Turner. Tucson: The University of Arizona Press, 1992.
Van den Boogerd, Dominic, Barbara Bloom, and Mariuccia Casadio, eds. *Marlene Dumas*. London: Phaidon Press, 1999.

Acknowledgments:

Thank you to Marlene Dumas for her close and patient collaboration in the writing of this essay. Without her good humor, warmth and fine nuances, and without her thousand and one facsimiles, I would have been at a loss! Thanks to Lou-Marié Kruger for her loving support during the writing period and her thematic input; to Hettie Scholtz, my language editor, for fine-tuning my English; and to Adriaan van Zyl for valuable references and advice on art historical and theoretical matters. –MvN

Plates

My Plek [My Place]
2000, oil on canvas
78 3/4 x 39 3/8 inches, 200 x 100 cm

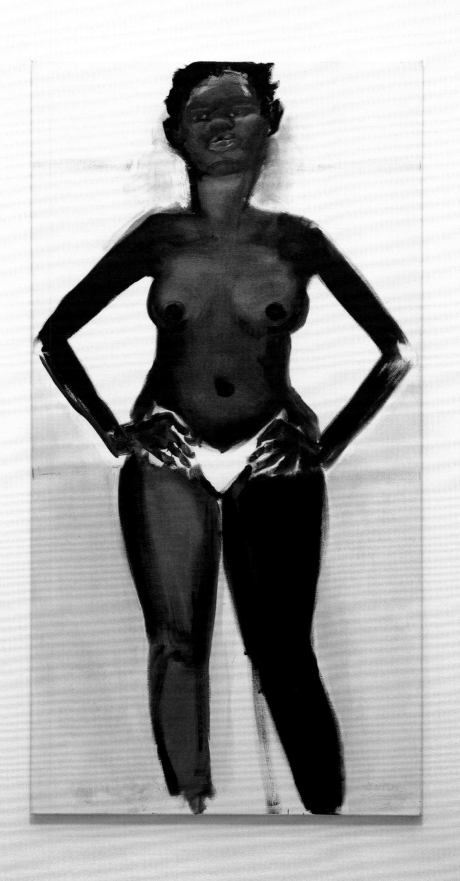

Ryman's Brides
1997, oil on canvas
51 3/16 x 43 5/16 inches, 130 x 110 cm

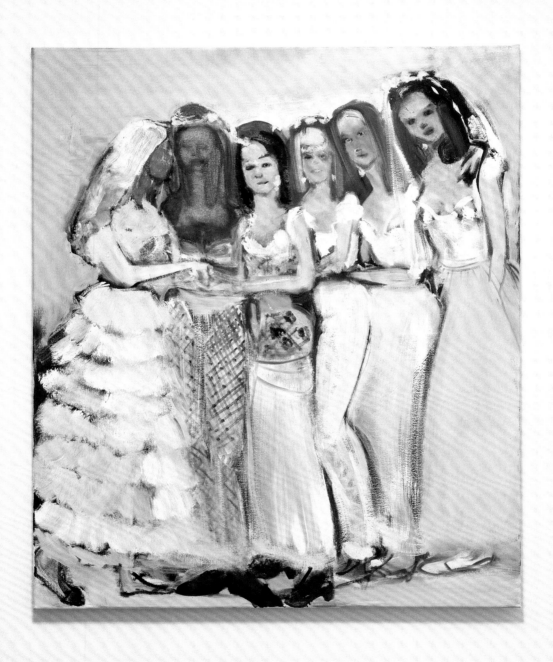

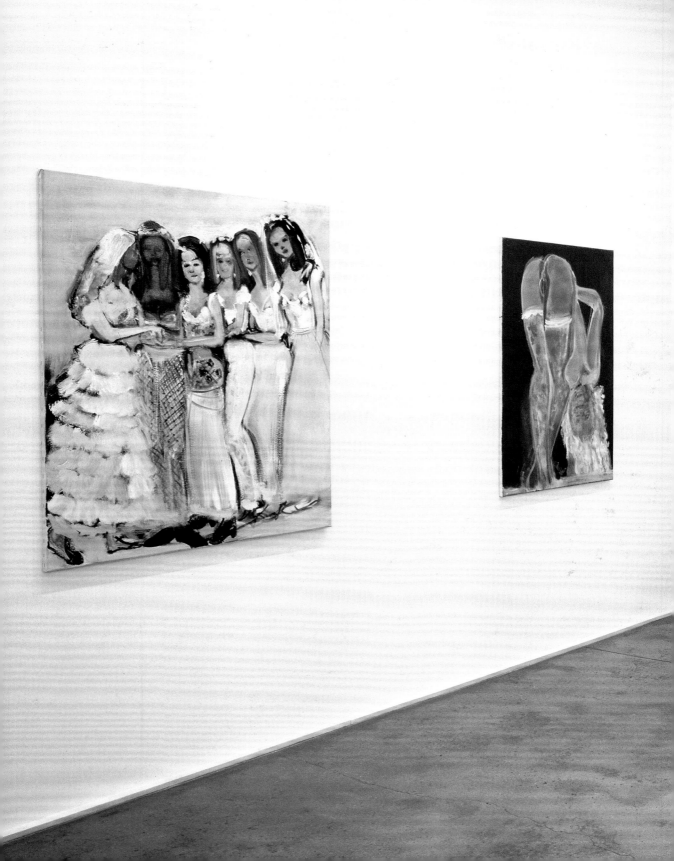

Couples
1994, oil on canvas
39 x 118 inches, 99.1 x 299.7 cm

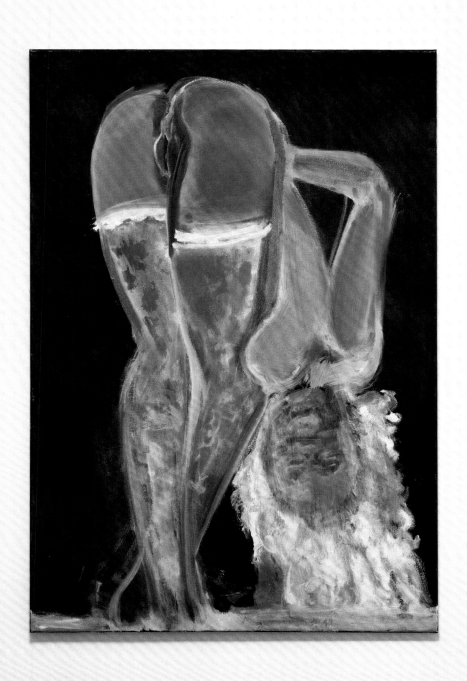

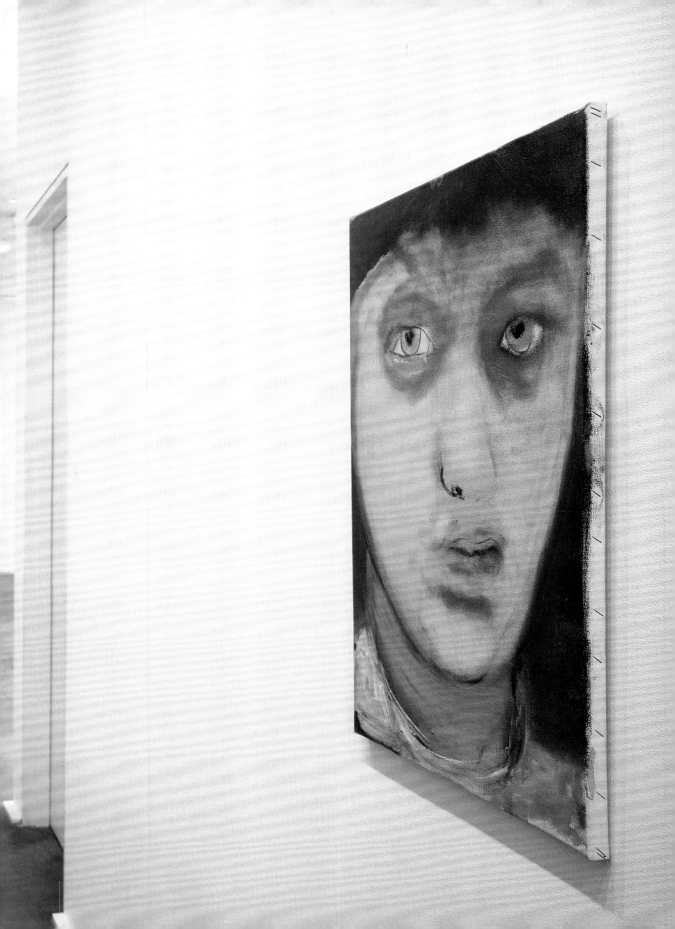

Face
1987, oil on canvas
20 x 27 inches, 50.8 x 68.6 cm

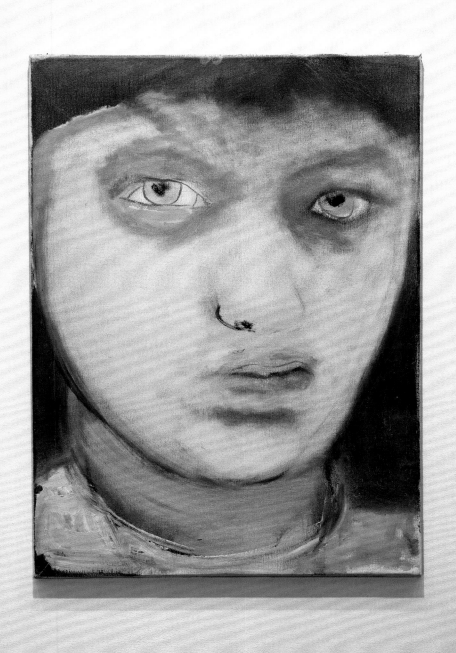

Baba (groot kop) [Baby (large head)]
1990, oil on canvas
10 x 14 inches, 25.4 x 35.6 cm

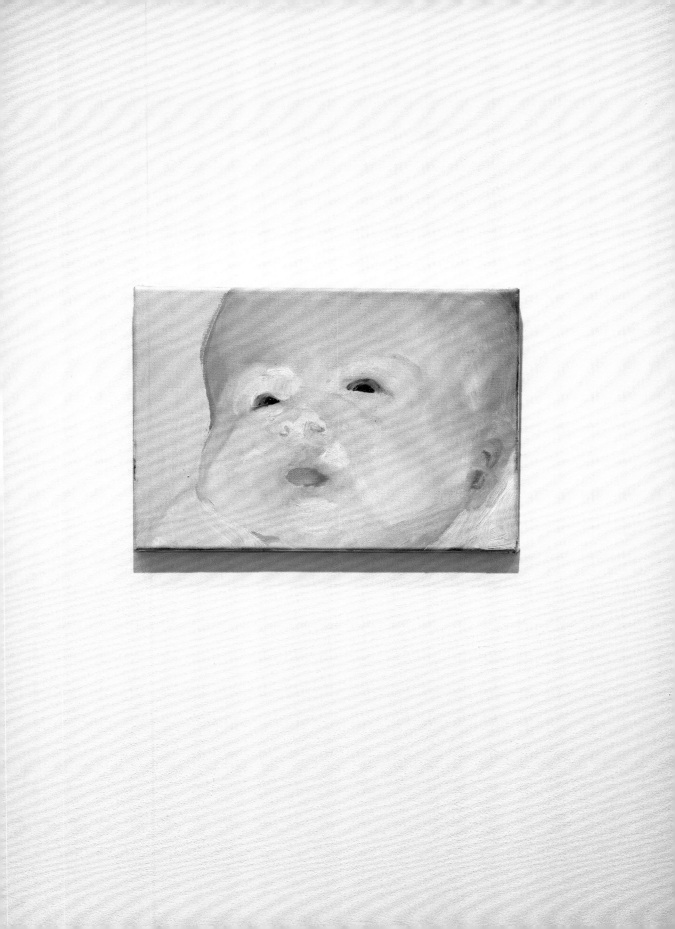

Double Bind
1993, oil on canvas
16 x 19 3/4 inches, 40.6 x 50.2 cm

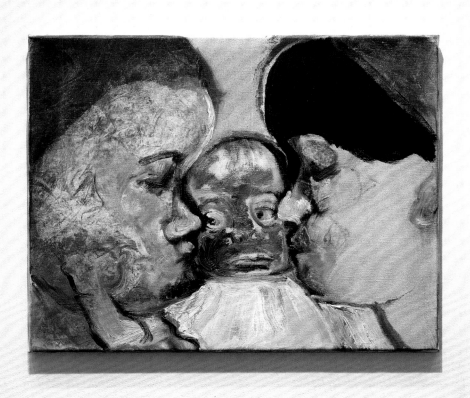

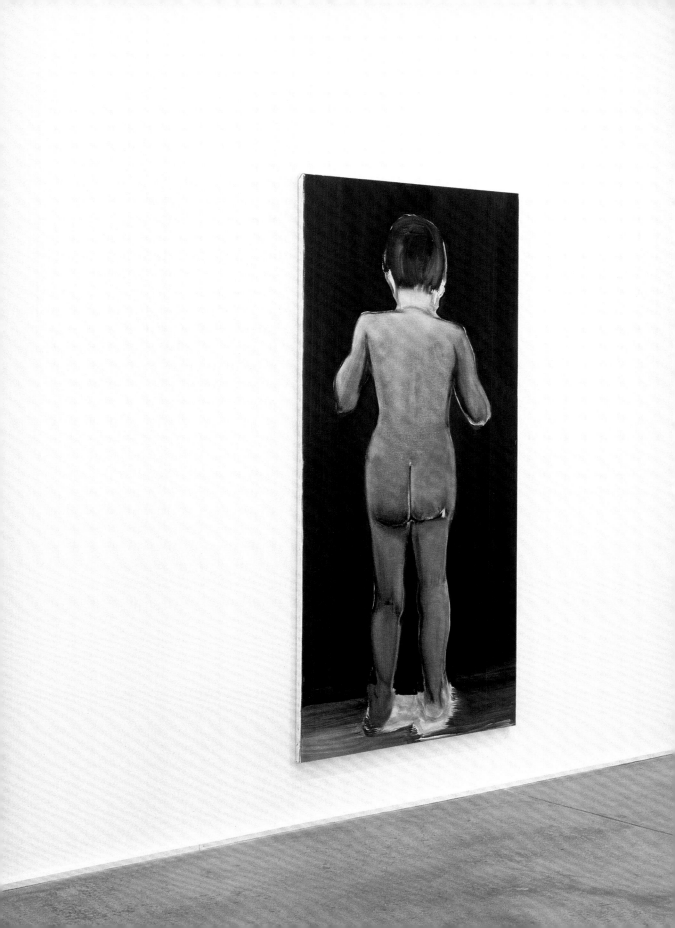

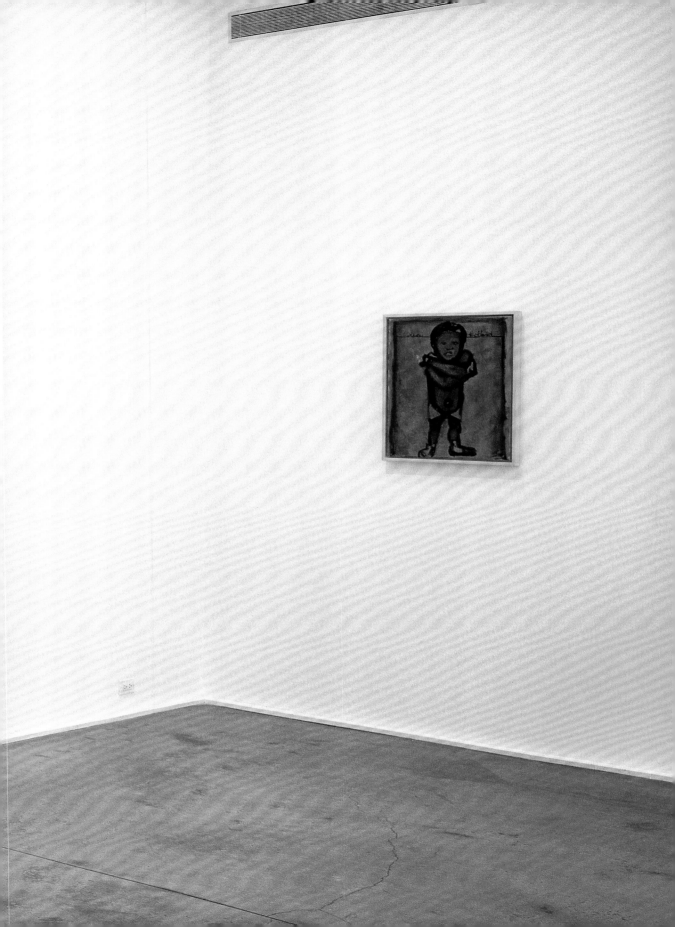

Untitled
1991, oil on canvas
23 3/4 x 19 3/4 inches, 60.3 x 50.2 cm

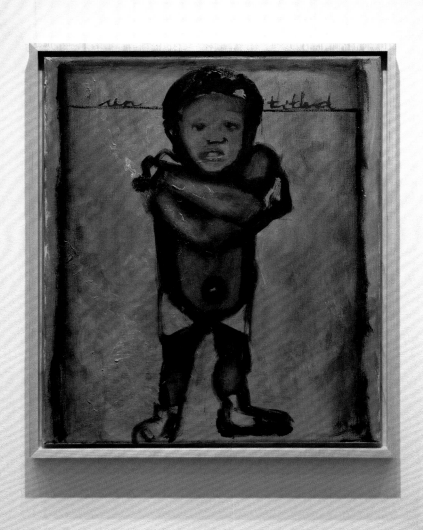

The Secret
1994, oil on canvas
78 3/4 x 39 1/4 inches, 200 x 99.7 cm

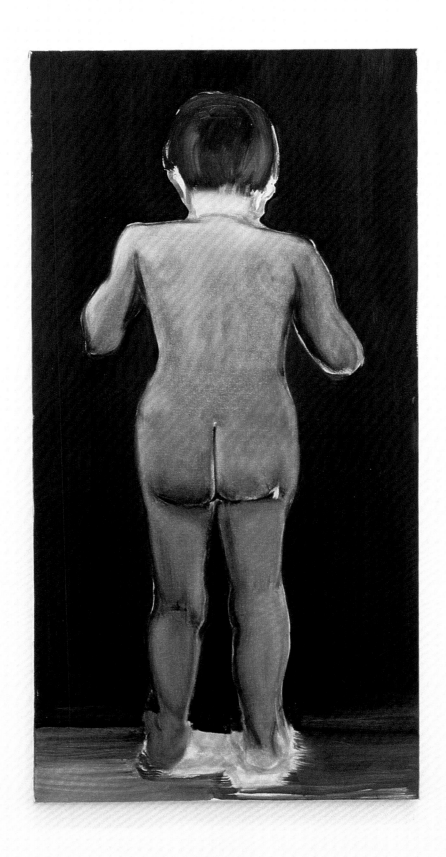

Reinhardt's Daughter
1994, oil on canvas
78 3/4 x 39 3/8 inches, 200 x 100 cm

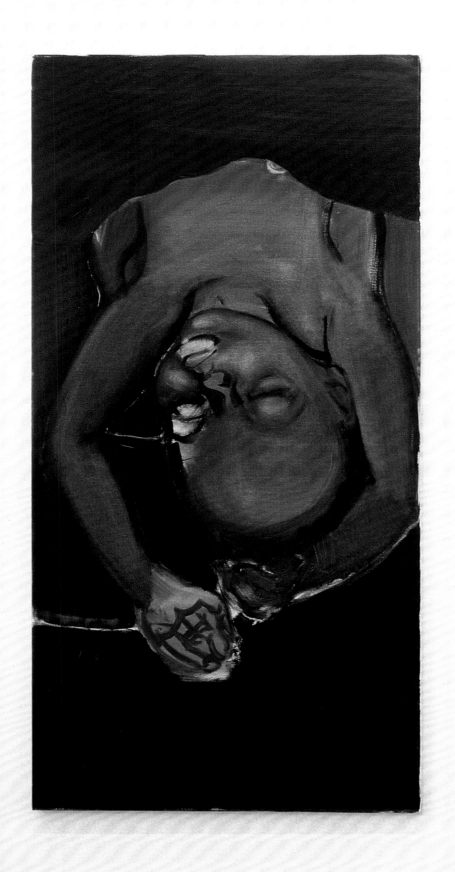

The Deceased
2002, oil on canvas
43 5/16 x 51 3/16 inches, 110 x 130 cm

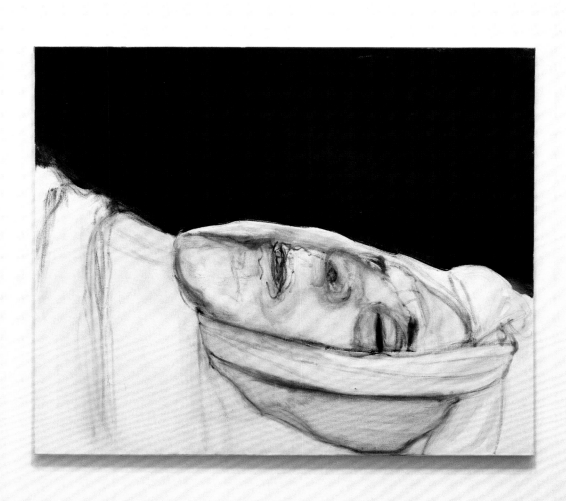

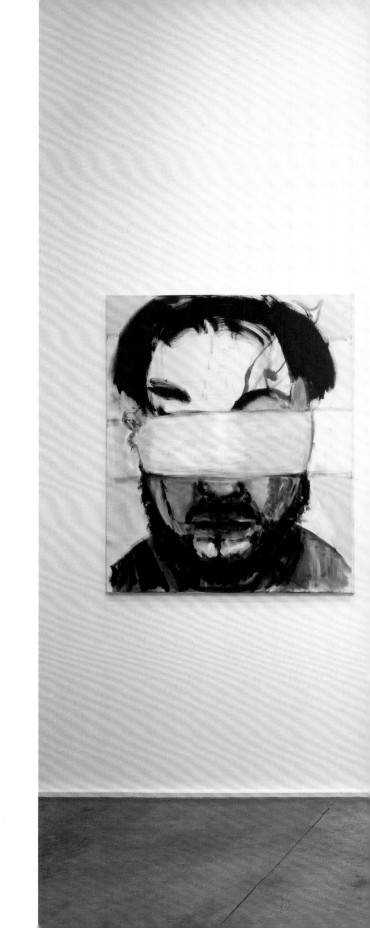

The Blindfolded
2002, oil on canvas, 3 panels
Each panel: 51 3/16 x 43 5/16 inches,
130 x 110 cm

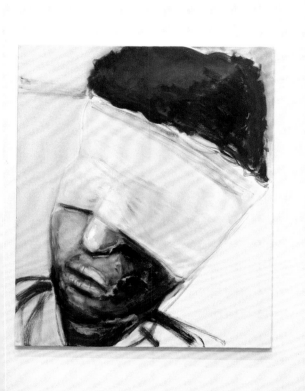
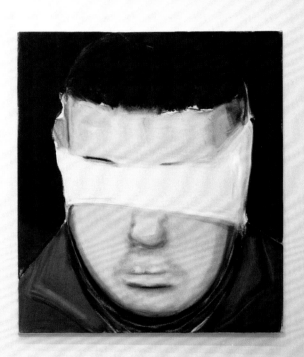

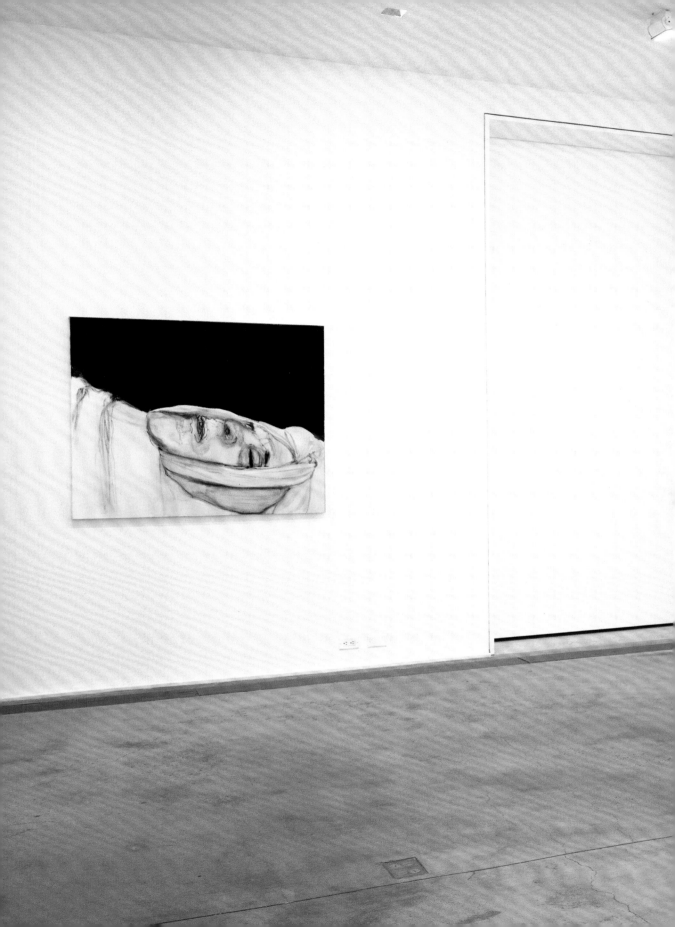

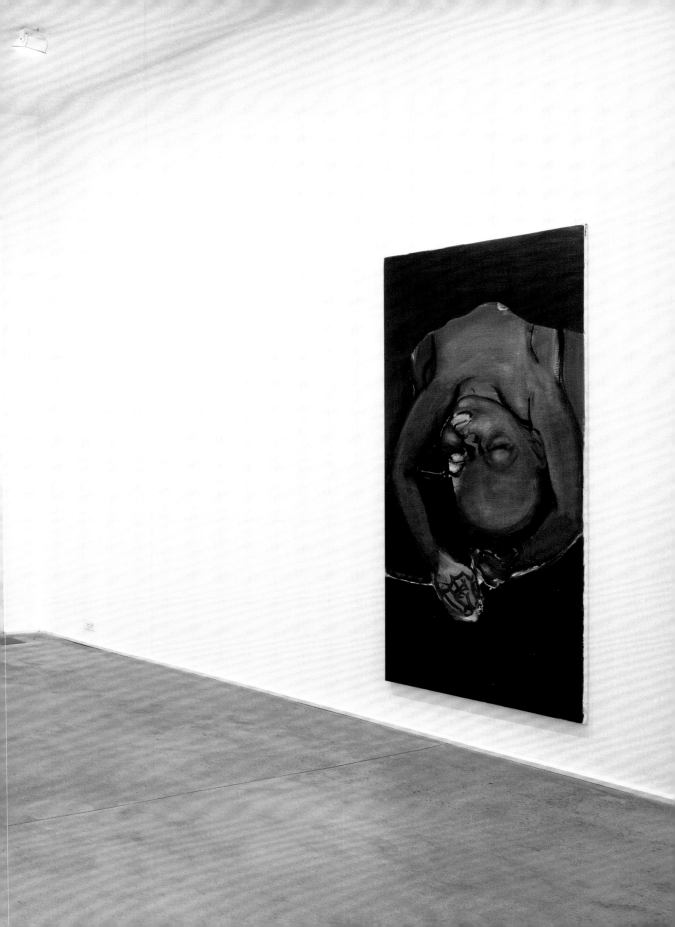

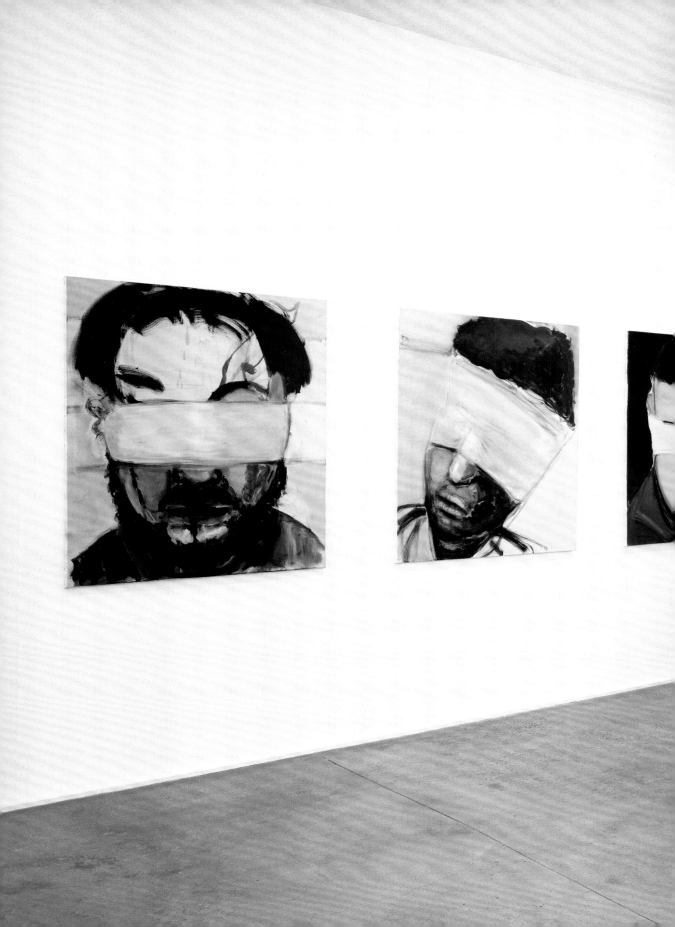

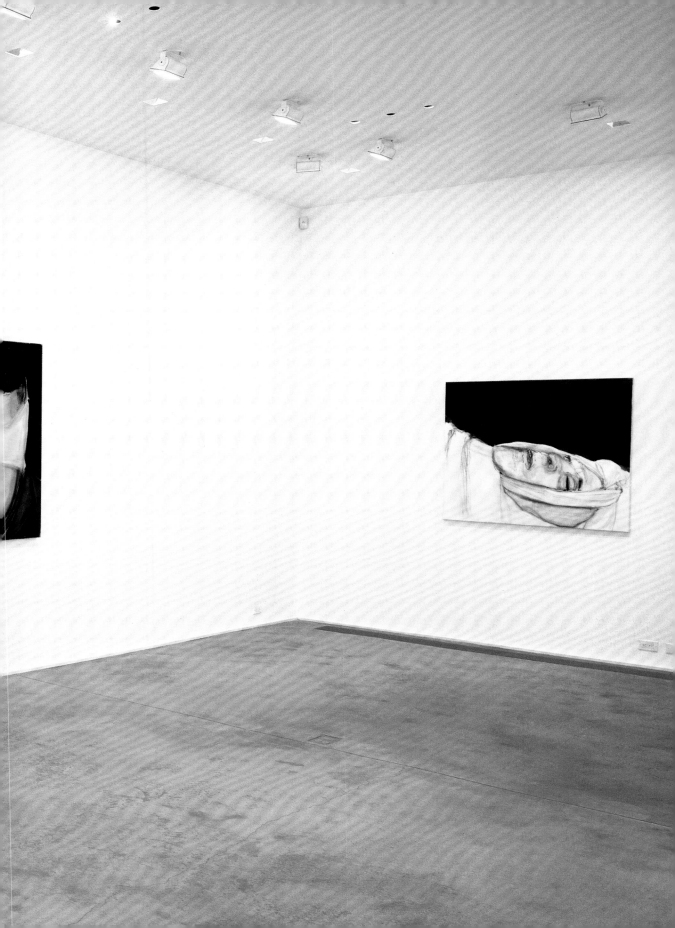

Works on Paper

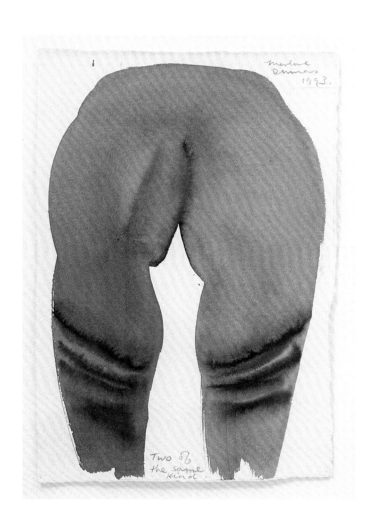

Two of the Same Kind
1993, watercolor on paper in two parts
One watercolor on paper
16 1/2 x 11 1/4 inches, 41.9 x 28.6 cm
Six watercolors on paper, framed together
12 1/4 x 9 1/2 inches (each), 31.1 x 24.1 cm

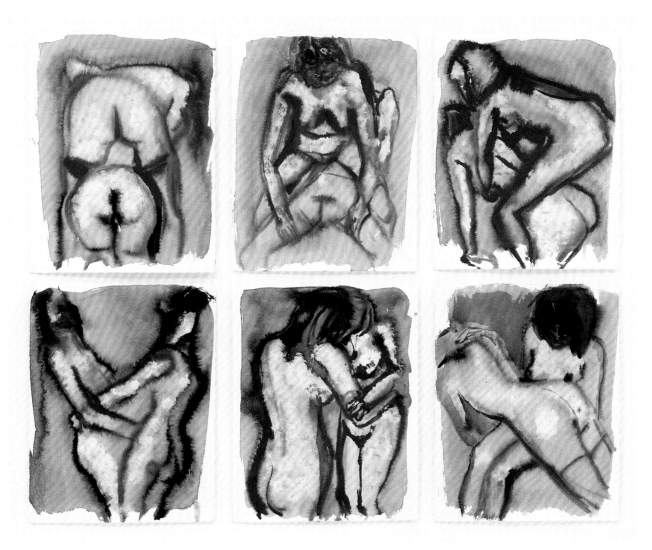

Thinking About Africa
1991, ink, crayon and collage on paper, 3 sheets
9 1/2 x 38 inches (each), 24 x 96.5 cm
Framed dimensions: 37 1/4 x 47 1/2 inches, 94.6 x 120.7 cm

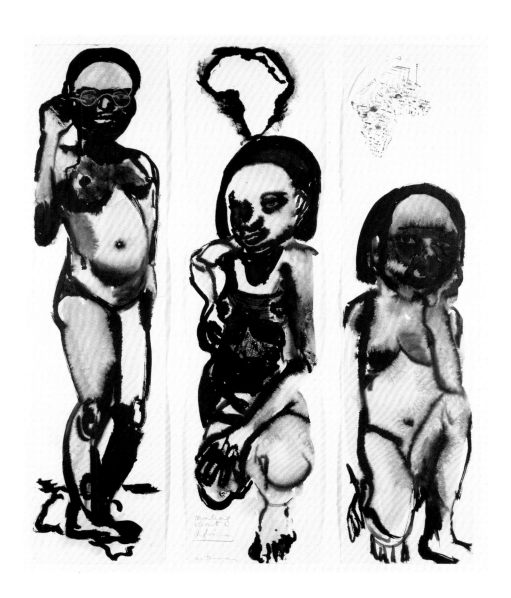

Voodoo Child
1996, ink and watercolor on paper
49 x 27 1/2 inches, 124.5 x 69.9 cm

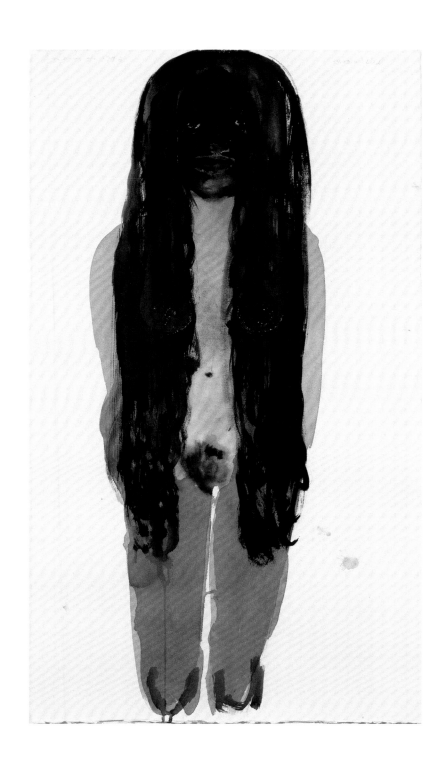

Oe.
1999-2000, watercolor on paper
20 x 24 inches, 50.8 x 61 cm

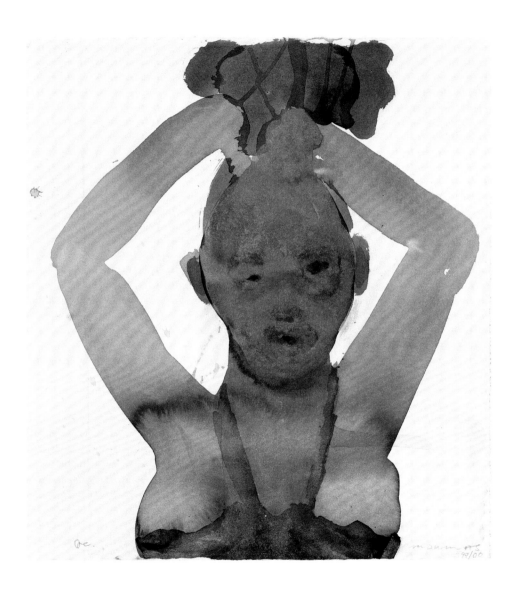

Head Rest
2001, watercolor on paper
26 x 19 1/2 inches, 66 x 49.5 cm

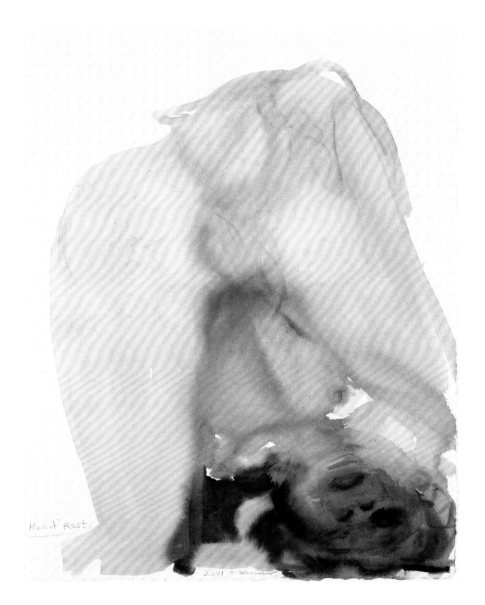

Head Rest.

2001

Loreley (the sage of the polluted Rhine)
1998, ink wash and watercolor on paper
48 7/8 x 27 inches, 124 x 70 cm

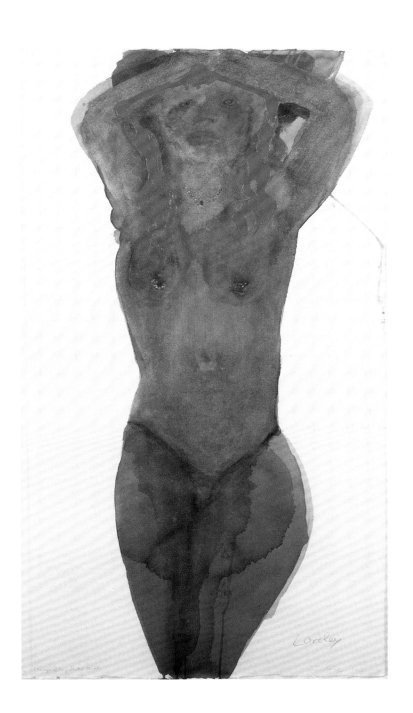

(Ver) wachtende [Expectant]
1989, ink, watercolor and pencil on paper
11 5/8 x 9 7/16 inches, 29.5 x 24 cm

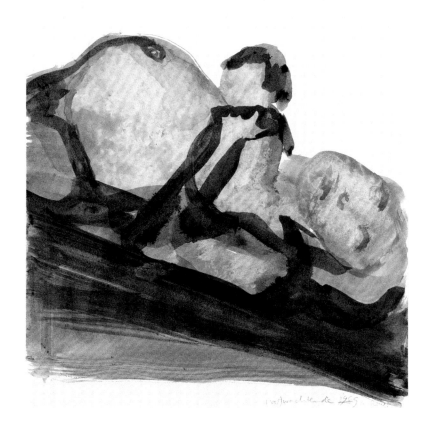

Bizarre (60's)
1993, watercolor and graphite on paper
10 5/8 x 7 7/8 inches, 27 x 20 cm

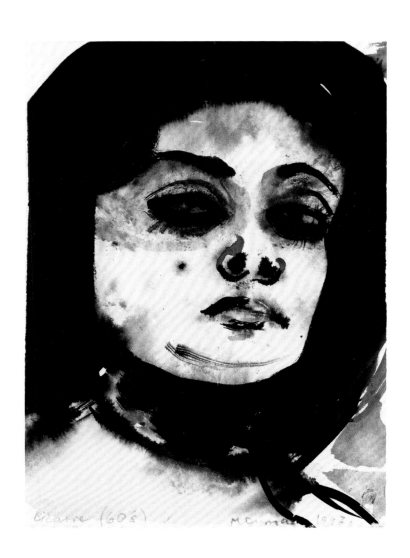

Bizarre (60's) / M tuman 1973

Diseases of the Eye
1991, ink, pencil and collage on paper, 4 sheets
9 1/4 x 6 1/4 inches (each), 23.5 x 15.9 cm
Framed dimensions: 26 1/4 x 22 1/4 inches, 66.7 x 56.5 cm

the sounds

The utter loneliness
of the human body.

In the absence of any distractions
you listen first to your bodily functions
the long-term prisoner said.

Contagious

people with glass eyes
collect ART

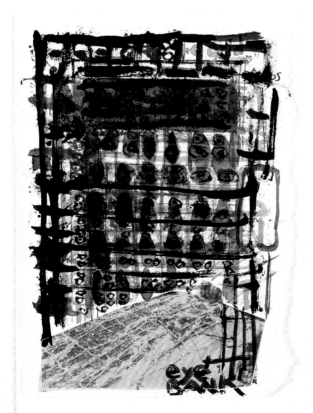

eye bank

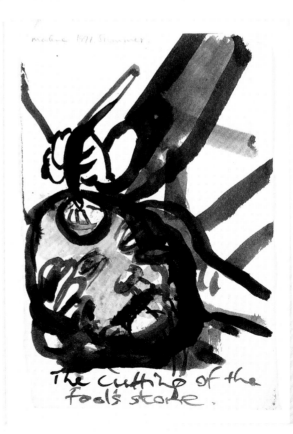

The cutting of the
fool's stone.

Die Familie (horisontaal) [The Family (horizontal)]
1990, ink on paper
10 13/16 x 16 3/4 inches, 27.5 x 42.5 cm

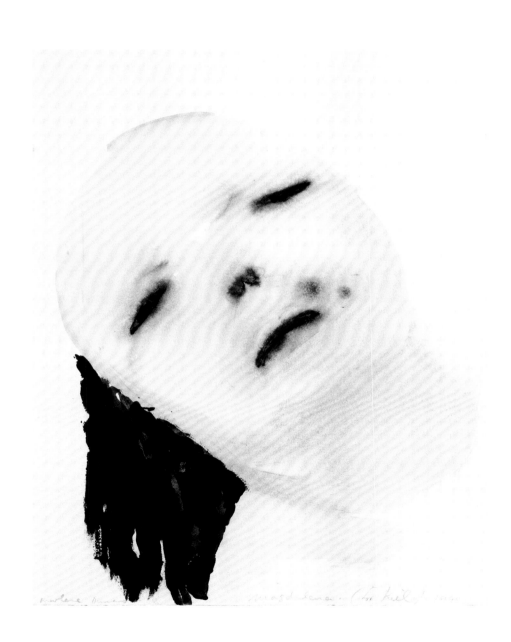

List of Works

My Plek [My Place]
2000, oil on canvas
78 3/4 x 39 3/8 inches, 200 x 100 cm
Private Collection

Ryman's Brides
1997, oil on canvas
51 3/16 x 43 5/16 inches, 130 x 110 cm
Private Collection

Couples
1994, oil on canvas
39 x 118 inches, 99.1 x 299.7 cm
Private Collection

Velvet and Lace (Schnabel meets Baselitz)
1999, oil on canvas
49 x 33 1/2 inches, 124.5 x 85.1 cm
Private Collection

Face
1987, oil on canvas
20 x 27 inches, 50.8 x 68.6 cm
Hort Family Collection

Baby (groot kop) [Baby (large head)]
1990, oil on canvas
10 x 14 inches, 25.4 x 35.6 cm
Hort Family Collection

Double Bind
1993, oil on canvas
16 x 19 3/4 inches, 40.6 x 50.2 cm
Collection Sharon and Michael Young

Untitled
1991, oil on canvas
23 3/4 x 19 3/4 inches, 60.3 x 50.2 cm
Private Collection

The Secret
1994, oil on canvas
78 3/4 x 39 1/4 inches, 200 x 99.7 cm
The Carol and Arthur Goldberg Collection

Reinhardt's Daughter
1994, oil on canvas
78 3/4 x 39 3/8 inches, 200 x 100 cm
Private Collection

The Deceased
2002, oil on canvas
43 5/16 x 51 3/16 inches, 110 x 130 cm
Private Collection

The Blindfolded
2002, oil on canvas, 3 panels
Each panel: 51 3/16 x 43 5/16 inches, 130 x 110 cm
Collection Hauser & Wirth, Switzerland

Works on Paper

Two of the Same Kind
1993, watercolor on paper in two parts
One watercolor on paper
16 1/2 x 11 1/4 inches , 41.9 x 28.6 cm
Framed dimensions: 21 3/4 x 16 inches,
55.2 x 40.6 cm
Six watercolors on paper, framed together
Each drawing: 12 1/4 x 9 1/2 inches,
31.1 x 24.1 cm
Framed dimensions: 30 3/4 x 35 inches,
78.1 x 88.9 cm

Thinking About Africa
1991, ink, crayon and collage on paper, 3 sheets
Each drawing: 9 1/2 x 38 inches,
24 x 96.5 cm each
Framed dimensions: 37 1/4 x 47 1/2 inches,
94.6 x 120.7 cm
Private Collection, San Francisco

Voodoo Child
1996, ink and watercolor on paper
49 x 27 1/2 inches, 124.5 x 69.9 cm
Collection Lenore and Rich Niles

Oe.
1999-2000, watercolor on paper
20 x 24 inches, 50.8 x 61 cm

Head Rest
2001, watercolor on paper
26 x 19 1/2 inches, 66 x 49.5 cm
Private Collection

Loreley (the sage of the polluted Rhine)
1998, ink wash and watercolor on paper
48 7/8 x 27 inches, 124 x 70 cm
Collection Frances Dittmer

(Ver) wachtende [Expectant]
1989, ink, watercolor and pencil on paper
11 5/8 x 9 7/16 inches, 29.5 x 24 cm

Bizarre (60's)
1993, watercolor and graphite on paper
10 5/8 x 7 7/8 inches, 27 x 20 cm
Collection Isabella del Frate Rayburn

Diseases of the Eye
1991, ink, pencil and collage on paper, 4 sheets
Each drawing: 9 1/4 x 6 1/4 inches,
23.5 x 15.9 cm each
Framed dimensions: 26 1/4 x 22 1/4 inches,
66.7 x 56.5 cm

Die Familie (horisontaal) [The Family (horizontal)]
1990, ink on paper
10 13/16 x 16 3/4 inches, 27.5 x 42.5 cm

A Dead Man
1987, watercolor, ink and black crayon on paper
11 1/2 x 8 1/4 inches, 29.2 x 21 cm

Magdalena
1995, watercolor on paper
18 1/2 x 14 7/8 inches, 47 x 37.7 cm
Collection Hauser & Wirth, Switzerland

Illustrations

1. *Mej Wêreld (Miss World)*
c.1963, colored pencil on paper
7 7/8 x 12 3/4 inches, 20 x 32.5 cm
Photograph courtesy Galerie Paul Andriesse

2. *Miss January*
1997, oil on canvas
118 1/8 x 39 3/8 inches, 300 x 100 cm
Photograph by Peter Cox, courtesy Galerie Paul
Andriesse / Rubell Family Collection

3. *Dorothy D-Lite*
1998, ink and acrylic on paper
49 3/16 x 27 9/16 inches, 125 x 70 cm
Photograph by Gert van Rooij, courtesy Zeno X
Gallery

4. *Francis Bacon − Marlene Dumas*
Castello di Rivoli, Torino, 1995
Installation view:
At left:
Marlene Dumas
Reinhardt's Daughter, 1994
At right:
Marlene Dumas
Cupid
1994, oil on canvas
51 3/16 x 43 1/8 inches (130 x 110 cm)
Photograph by Paolo Pellion di Persano, courtesy
Marlene Dumas

5. *The Painter*
1994, oil on canvas
78 3/4 x 39 3/8 inches, 200 x 100 cm
Photograph by Erma Estwick, courtesy Jack Tilton
Gallery

Cover: *Marlene Dumas − Selected Works*
Installation view, Main Gallery
Zwirner & Wirth, New York, 2005

Page 3: *Marlene Dumas − Selected Works*
Installation view, Front and Main Galleries
Zwirner & Wirth, New York, 2005

Page 31: *Marlene Dumas − Selected Works*
Installation view, Front Gallery
Zwirner & Wirth, New York, 2005

Pages 36-37:
Marlene Dumas − Selected Works
Installation view, Reception Area and Main Gallery
Zwirner & Wirth, New York, 2005

Pages 44-45, and 56-57:
Marlene Dumas − Selected Works
Installation views, Main Gallery
Zwirner & Wirth, New York, 2005

Page 90-91: *Marlene Dumas − Selected Works*
Installation view, 2nd Floor Gallery
Zwirner & Wirth, New York, 2005

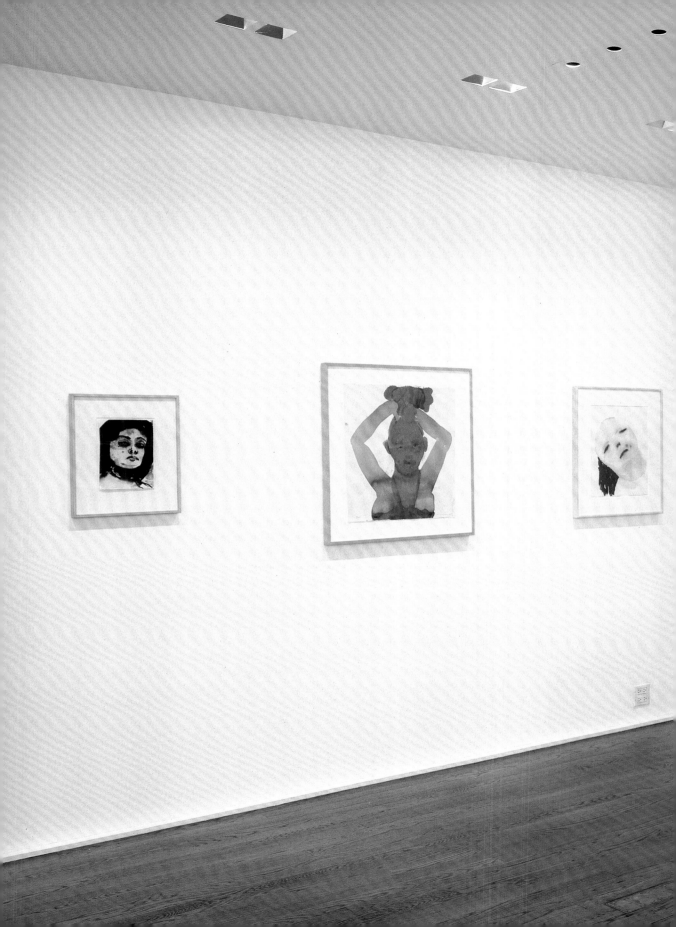

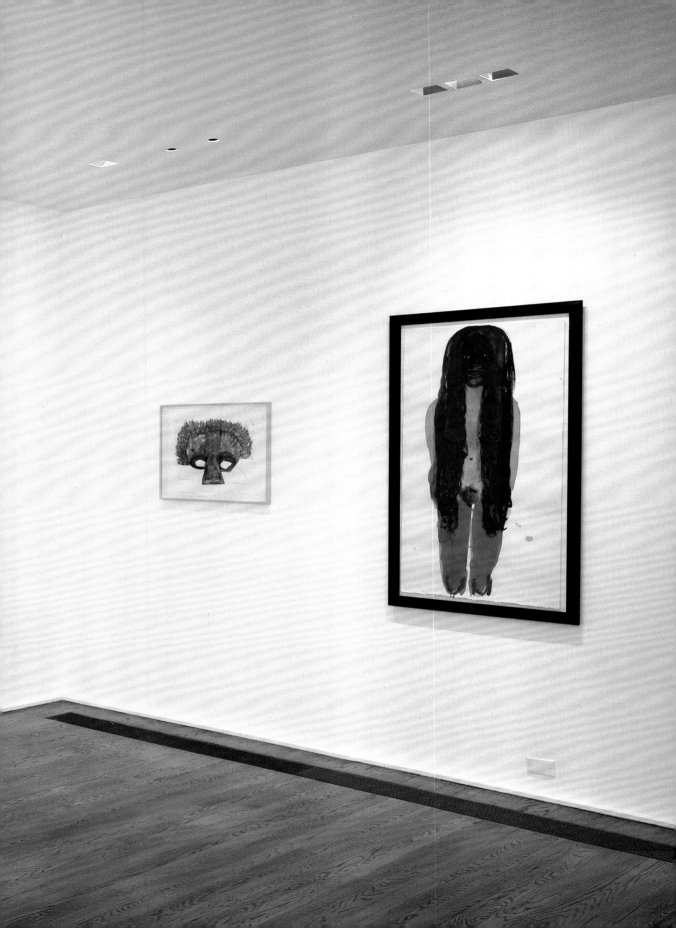

We wish to express our warmest gratitude to Marlene Dumas, who has been indispensable in the planning and execution of this exhibition and catalogue, and special thanks are due to Jolie van Leeuwen for her invaluable contribution. We would also like to thank all of the collectors who have so generously lent us their paintings and drawings, and without whom we could not have assembled such a wonderful selection of works. Moreover, we are sincerely grateful to Marlene van Niekerk, whose insightful and original essay makes this catalogue like no other.

We would also like to thank Sam Martineau and Kelly Reynolds for their dedicated efforts in the preparation and installation of this exhibition.

Editors: Kristine Bell, Greg Lulay, and Alexandra Whitney
Copy Editor: Nadine Covert
Exhibition Installation: Sam Martineau and Ian Umlauf
Plate photography: Ben Cohen, except *Loreley*: Robert Millman
Installation photography: Joshua Nefsky
Design: Matthew Polhamus
Printing: ColorCoded, NY

ZWIRNER & WIRTH

32 E 69 St New York NY 10021
212.517.8677 t / 212.517.8959 f www.zwirnerandwirth.com

This catalogue accompanies the exhibition at Zwirner & Wirth
Marlene Dumas – Selected Works
February 18–April 23, 2005

All works by Marlene Dumas © Marlene Dumas
Essay: © 2005 Marlene van Niekerk
ISBN 0-9708884-8-1